P9-ASK-213

Renaissance Art

NATHANIEL HARRIS

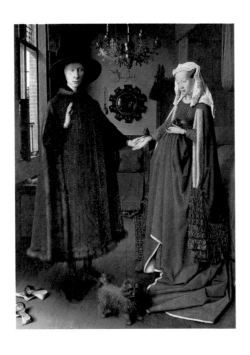

LIBRARY
FRANKLIN PIERCE COLLEGE
RINDGE, NH 03461

Thomson Learning

New York

ART AND ARTISTS

Ancient Art
Art in the Nineteenth Century
Renaissance Art
Western Art 1600-1800

Cover picture *Madonna of the Rocks* by Leonardo da Vinci. *Musée du Louvre, Paris.*

Title page *The Arnolfini Wedding* by Jan van Eyck. *National Gallery, London.*

Series and book editor: Rosemary Ashley
Designer: Simon Borrough

First published in the United States in 1994 by
Thomson Learning
115 Fifth Avenue
New York, NY 10003

First published in Great Britain in 1994 by
Wayland (Publishers) Limited

U.K. version copyright © 1994 Wayland (Publishers) Ltd.

U.S. version copyright © 1994 Thomson Learning

Library of Congress Cataloging-in-Publication Data
Harris, Nathaniel.
 Renaissance art / Nathaniel Harris.
 p. cm.—(Art and artists)
 Includes bibliographical references and index.
 ISBN 1-56847-217-X
 1. Art, Renaissance—Juvenile literature. [1. Art,
Renaissance.] I. Title. II. Series: Art and artists
(Thomson Learning (Firm))
 N6370.H27 1994
 709'.02'4—dc20 94-6080

Printed in Italy

Picture acknowledgments

The photographs in this book were supplied by: Archiv für Kunst und Geschichte *cover, title page,* 5, 6, 8 (both), 10-11, 13 (left), 14, 16, 17, 18-19, 21, 22 (both) 23, 25, 26 (left), 27, 28, 30, 31, 32 (both), 33, 34 (left) 35, 36, 38-39, 41, 42, 43 (both), 44, 45 (right); Bridgeman Art Library *cover,* 4, 12, 13 (right), 24, 29, 37, 45, (left); E. T. Archives 15; Mary Evans *cover:* K&B News Foto © Giuliano Valsecchi 9, 19, 40 (left), © Nicolo Orsi Ballaglini 26 (right), © N. Buonafede 40 (right); Wayland Picture Library/British Museum 7, /National Gallery 11, /Royal Library, Windsor 34 (right), /Julia Davey 43 (right).

CONTENTS

1 WHAT WAS THE RENAISSANCE?

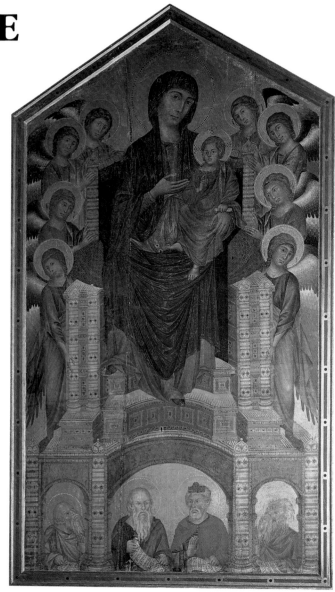

Right *Madonna Enthroned*, by Florentine artist Giovanni Cimabue. In this painting, from around 1280, the artist's approach is still basically medieval. The enlarged size of the Virgin Mary and the infant Jesus, the halos, and the lavish use of gold are intended to give the viewer a feeling of awe. *Uffizi Gallery, Florence, Italy.*

Far right *Madonna of the Meadows* by Raphael, one of the greatest artists of the Renaissance (see page 36). His painting of the Madonna is very different from medieval works like Cimabue's *Madonna* (near right). Raphael portrays the holy figures in a fresh, natural style as completely human, in an earthly landscape. *Museum of Art, Vienna.*

The Renaissance was one of the great ages of European art. At its height, during the fifteenth and sixteenth centuries, there were amazing new developments in painting, sculpture, and architecture. Dozens of splendidly gifted artists appeared on the scene, including some of the most famous names in art, such as Leonardo da Vinci and Michelangelo. The center of the Renaissance was Italy, although after about 1500, Renaissance ideas and techniques spread throughout the rest of Europe. This period changed the history of art.

Renaissance means "rebirth," a word that describes the new ideas and fresh attitudes of the people who lived during this period. The great works of art produced by painters, sculptors, and architects during the Renaissance were not the only achievements of the period. The "rebirth" affected literature, education, medicine, science, and many other subjects. The Renaissance introduced a new set of values, which changed the way people thought about the world and their place in it.

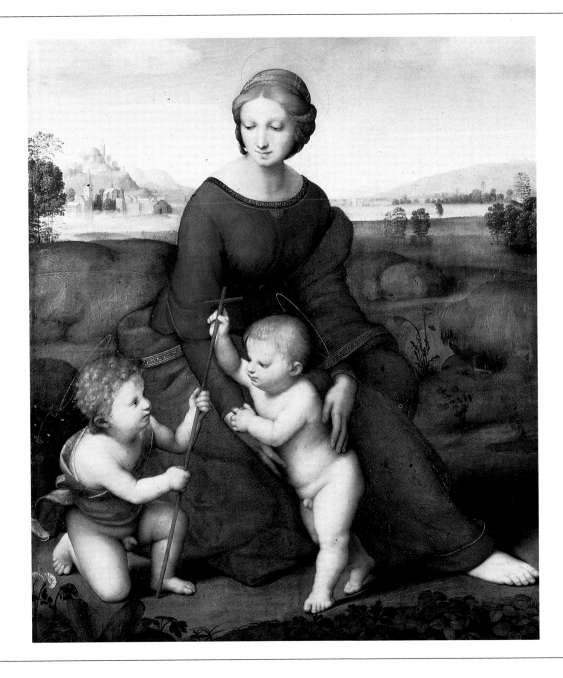

Renaissance thinkers believed that human beings were capable of great achievements – "man can do all things" – and that every kind of talent and skill was worth developing. The great figures of the Renaissance were very aware of their own importance, and they were also intensely interested in the world around them and in every form of human activity.

Today we take these attitudes for granted. But at the time of the Renaissance this "human-centered" attitude was new in Christian Europe. During the thousand-year period leading up to the Renaissance, known as the Middle Ages, people had thought about life in a very different way. They saw it mainly as a preparation for heaven or hell rather than an experience worth having for its own sake. As far as worldly matters were concerned, people were viewed in terms of their place in society – for instance, as good or bad kings or princes, knights, nuns, or priests – rather than as individuals.

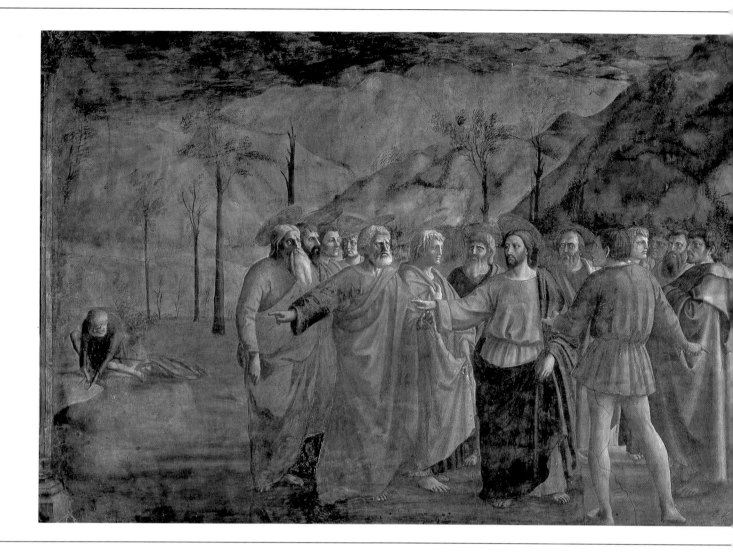

Different attitudes toward life produce different kinds of art. Most medieval pictures were not intended to show everyday happenings. They were pictures of sacred Christian figures such as the Virgin Mary or Jesus Christ, often portrayed as larger – because they were more important – than ordinary human beings who were shown with them. In some cases the backgrounds of these religious pictures were covered with pure gold, to indicate that the events were not taking place in the real world but in God's kingdom. Later in the Middle Ages, there was more interest in the natural world, especially in the illuminations (book illustrations) painted by monks in the style of International Gothic. These are fresh and charming, with a strong feeling for decoration and pattern.

But we are in a different world with early Renaissance paintings such as Masaccio's *The Tribute Money* (c. 1427). Masaccio shows Jesus and his disciples as believable human beings, their emotions communicated by their attitudes, gestures, and facial expressions. The figures are convincingly solid, and there is a definite sense of space stretching away from them. This painting shows how Renaissance art tried to capture the world of nature and humanity as exactly as possible. This approach to art is called naturalism, and its development during the Renaissance had tremendous consequences for future styles of art. The impact of the Renaissance was so great that, in one form or another, naturalism dominated European art all the way to the twentieth century.

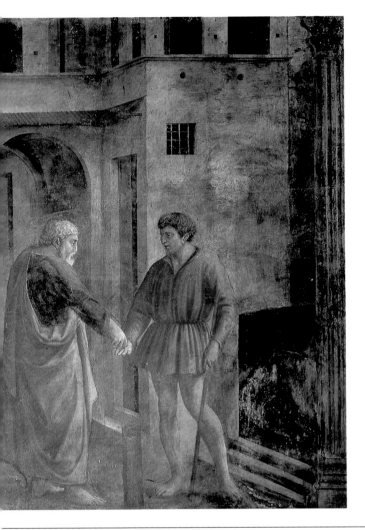

Above A late medieval manuscript painting, full of enchanting details, that shows a growing awareness of the everyday world. Manuscript paintings are called illuminations.

Left *The Tribute Money* by Masaccio (1401-28), who was the first great Renaissance painter. The figures in this dramatic scene are solid and three-dimensional. *Chapel of Santa Maria del Carmine, Florence.*

Naturalism is now considered only one of many approaches to art. The kind of medieval art described above, inspiring feelings of awe and mystery, is as valid as any other form of art. But that was not how Renaissance thinkers and artists felt. To them, the Middle Ages were dark times from which they had at last emerged into the glorious light. In fact, Renaissance writers invented the idea of the Middle Ages – "middle" because it was seen as a barbaric period separating the Renaissance from the glorious civilization of ancient Greece and Rome.

Greco-Roman civilization, also known as the classical world, had an immense influence on the Renaissance – on the way people behaved as well as what they thought, wrote, and created. This was why Renaissance people

spoke of their own time in terms of a rebirth: they felt that they were not doing something entirely new, but returning to the true values of the ancient Greeks and Romans. The importance of the classical period for Renaissance art is discussed separately in chapter 3 of this book.

Italians were especially aware of the classical past, since their country had been the center of the Roman Empire, and its ruined monuments were all around them. But this was not the only reason why the Renaissance began in Italy. The cities of Northern Italy were thriving centers of production and international trade at a time when most of Europe was still feudal and agricultural. Some of the greatest cities – Florence, Milan, Venice, and others – were

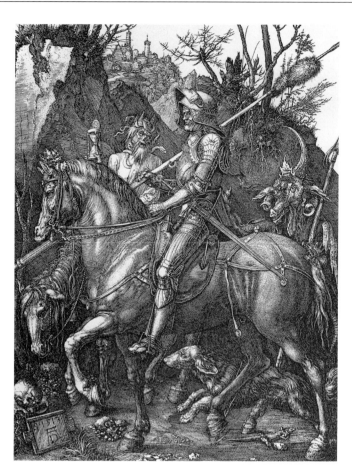

Above *Knight, Death and the Devil*, an engraving by the German artist Albrecht Dürer. Dürer (see pages 44 and 45) was one of the earliest north European artists to be influenced by the Renaissance.

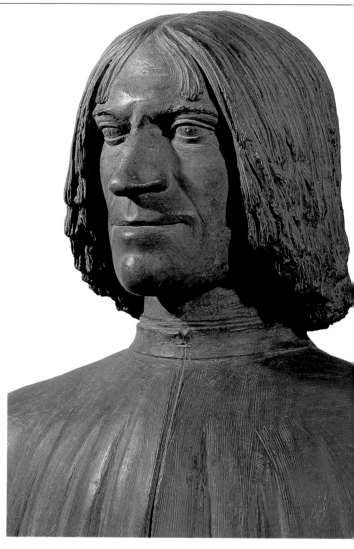

independent city states, controlling large territories beyond their walls. The city of Rome was admired for its past greatness as the capital of the Roman Empire, but it also continued to be important as the headquarters of the Pope, the head of the western Christian Church.

The energetic atmosphere of life in the city-states encouraged new ideas and provided artists with wonderful opportunities. As in the Middle Ages, they found patrons (people who would order and pay for works of art) among long-established groups such as nobles and churchmen. But now wealthy merchants also became generous patrons, and so did city rulers, who were eager to make their cities more beautiful than those of their rivals.

Patrons of the arts

The most famous Renaissance family was probably the Medici family of Florence. They were wealthy bankers who ruled the city-state for long periods. Lorenzo de' Medici (1449-92) was particularly celebrated as a diplomat, a poet, and the patron of artists such as Botticelli and Michelangelo. Other great Renaissance patrons included the Gonzaga family of Mantua and Federigo da Montefeltro at Urbino.

There was fierce competition for the services of the best artists, who were no longer looked down on as mere workmen but were treated with a new respect.

Right A bronze panel by Lorenzo Ghiberti showing a scene from the Bible, from the Baptistery doors in Florence.

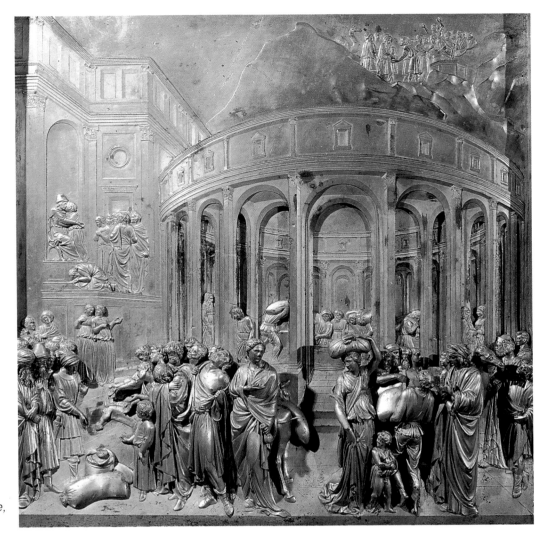

Left *Portrait of Lorenzo de' Medici* by Antonio Pollaiuolo. Lorenzo was easily the most celebrated of the Medici family, becoming known as Lorenzo il Magnifico (the Magnificent). *National Gallery, Prague, Czech Republic.*

The first great Renaissance city was Florence. Although the new art developed gradually out of the old, the Renaissance really emerged early in the fifteenth century with the work of four Florentines: the sculptors Ghiberti and Donatello, the painter Masaccio, and the architect Brunelleschi.

In the course of the fifteenth century many other artists and cities played their part in the Renaissance. The movement reached new heights in the High Renaissance, with Leonardo da Vinci, Michelangelo, and Raphael. The main center for these artists was Rome. The Italian Renaissance finally ended in 1527, except for a late flowering in Venice, where Titian and other leading painters worked.

Renaissance pioneer

In 1401 Lorenzo Ghiberti (1378-1455) won a competition held to decide who should make a pair of large bronze doors for the Baptistery of Florence Cathedral. Ghiberti's doors were so popular that he was commissioned to make a second pair. Nicknamed "Gates of Paradise," these two great works, which took him over fifty years to complete, show how he learned from the new discoveries about perspective and architecture.

But by that time Renaissance ideas and the Renaissance style had spread into northern Europe, influencing European art for centuries to come.

2 ARTISTS AT WORK

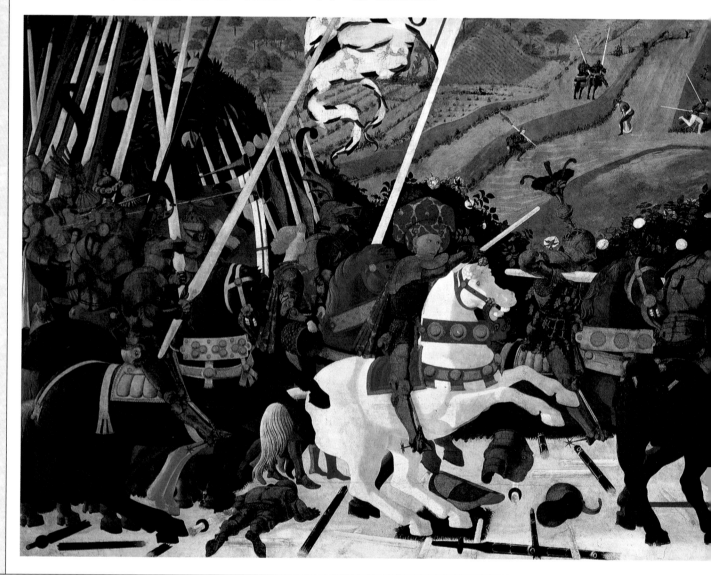

Artists normally work with the materials and techniques that are readily available in their own time. There is usually a close connection between such materials and techniques and the style of a particular period. So it is not surprising that when there is a big change in attitudes to art – such as during the Renaissance – there are important technical developments.

Many of the new effects achieved by Renaissance artists were the result of intensive

study. This was especially true of perspective, the science of showing objects in space on a two-dimensional (flat) surface. If a picture is to give an illusion of reality, it must have depth; that is, the scene it shows must appear to stretch away into the distance.

To some extent, artists were able to suggest depth by showing objects at the front of an imaginary space as larger than those farther back, or by making the foreground objects overlap those behind them. But to show really

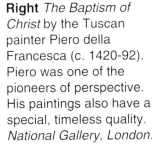

Left *The Battle of San Romano* by Paolo Uccello. Uccello, who was a Florentine, recorded one of his city's long-forgotten victories in a colorful decorative style. "Uccello" is a nickname, meaning "bird." *National Gallery, London.*

Right *The Baptism of Christ* by the Tuscan painter Piero della Francesca (c. 1420-92). Piero was one of the pioneers of perspective. His paintings also have a special, timeless quality. *National Gallery, London.*

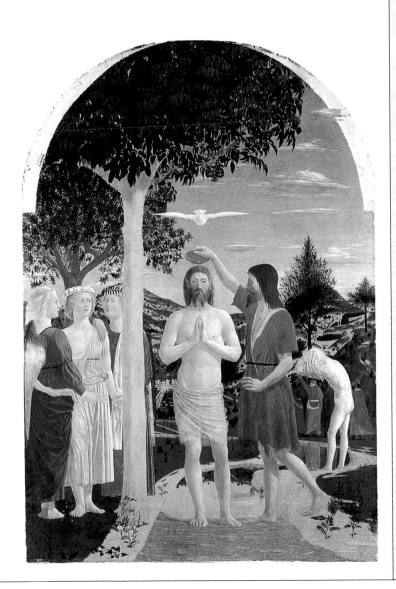

convincing depth they had to use the principles of linear perspective. These were based on the fact that when parallel lines move away from the viewer, they appear to approach each other and meet at a "vanishing point" on the horizon. At the beginning of the fifteenth century a mathematical system of perspective was worked out by the Florentine architect Filippo Brunelleschi and improved by Paolo Uccello, Piero della Francesca, and others. This system made a great impression on artists, and some became obsessed by perspective

problems; Uccello's wife complained that he stayed up all night working on vanishing points, and that when she called him to bed he would only say, "Oh what a lovely thing this perspective is!"

Renaissance painters also studied aerial perspective. Aerial perspective uses the fact that the farther away an object is, the more faded and "cool" its colors seem; distant mountains, for example, generally look blue and misty. Artists were also able to create more

Dead Christ by Andrea Mantegna (1431-1506). In this painting Mantegna has created dramatic effects of perspective by foreshortening the body of Christ, showing his features on the pillow and his feet projecting toward the viewer. *Brera Gallery, Milan, Italy.*

solid-looking figures by studying the way in which light and shadow could be used to pick out the shapes of facial features or the fall of drapery. And some learned from the study of anatomy, which was just becoming recognized as a science.

Renaissance art was also greatly influenced by the perfecting of the technique of fresco and by the introduction of oil paints. Fresco was used

for paintings done on walls and ceilings (murals). Murals had been popular for centuries as a way of decorating interiors, though sooner or later the paint tended to flake away from the plastered surface of the wall. But the new fresco technique – *buon fresco* – used in Italy from the fourteenth century was a great improvement. Its main feature was the application of a final layer of fresh plaster (fresco is Italian for "fresh") that

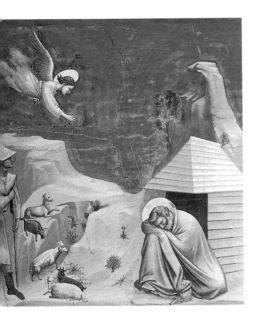

Above *The Dream of St. Joachim* by the medieval Florentine painter Giotto (c. 1266-1337). This is one of a series of pictures by Giotto painted on the walls of the Arena Chapel, Padua. Giotto used the fresco technique and his works still look amazingly fresh and brilliant.

Right *Martyrdom of St. Sebastian* by Antonio Pollaiuolo. Antonio and his brother Piero studied anatomy and the problems of representing violent movement. In this painting great attention is paid to the muscular poses of the figures. The Pollaiuolo brothers' workshop was one of the most successful in Florence in the second half of the fifteenth century. *National Gallery, London.*

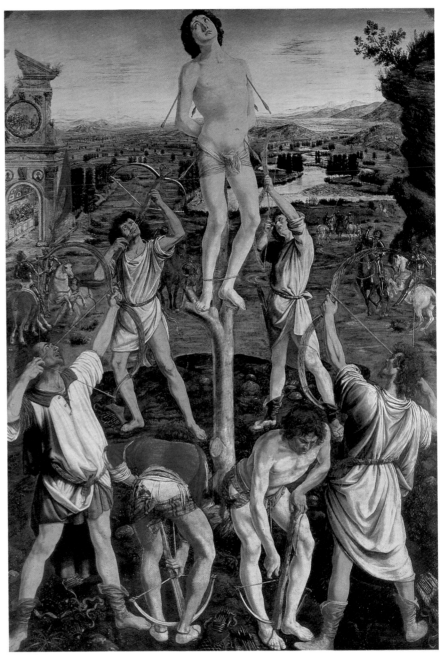

the artist painted on while it was still wet. As it dried, the plaster and the colors became chemically bonded, so there was no danger of the picture flaking. A painting done with this technique is commonly called a fresco. Because the fresco had to be painted while the plaster was wet, it was essential for the artist to work quickly, without much retouching or trying to put in too much detail. So fresco was used to create large, grand, and dramatic effects.

Frescoes were painted with pigments (colored materials) and water. Until late in the fifteenth century, most other kinds of Italian painting were done on wooden panels, with a medium known as tempera. This consisted of pigments mixed with egg yolk and water. The effect could be brilliant, and some of the finest Renaissance pictures were painted in tempera; although, like fresco, it had the disadvantage of drying quickly.

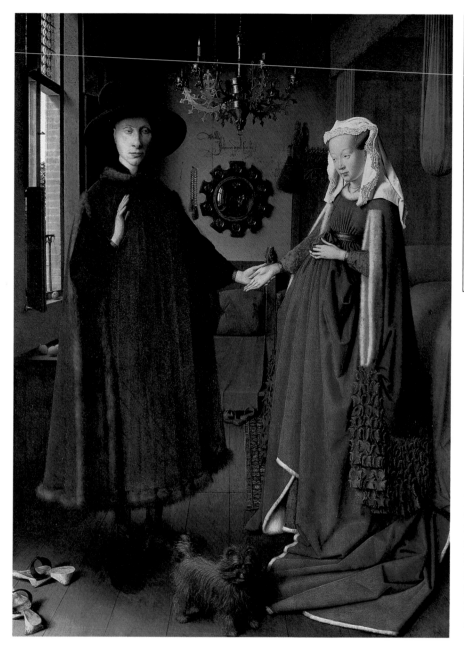

Flemish painting
Fifteenth-century Flanders (roughly modern Belgium) produced a number of great painters with their own brand of naturalism. Oil painting was first developed in Flanders, and was used with supreme skill by Jan van Eyck (c.1385-1441). Works such as *Man in a Red Turban*, *Madonna of the Fountain*, and *Arnolfini Wedding* (left) reveal his mastery of fine detail and brilliant color.

Left *Arnolfini Wedding* by Jan van Eyck. This beautiful painting, solemn yet tender, is full of exquisite details – including a mirror that reflects the entire scene in miniature. *National Gallery, London.*

Right *Ganymede Mounting Zeus* by Benvenuto Cellini (1500-71) shows the fine detail and freedom sculptors could achieve when working in bronze. This subject is taken from a Greek myth about the boy Ganymede being carried off by the god Zeus, who has taken the form of an eagle. *Bargello Gallery, Florence.*

By the 1470s Italian artists were beginning to experiment with a new technique, using oil. Oil painting was not an Italian invention, but was borrowed from Flemish artists who had developed their own type of art. When pigments were mixed with oil (usually linseed), they dried very slowly. The artist could build up the picture layer by layer, correcting mistakes and achieving great detail and finish. This was only one of the many effects that could be obtained with oils, as great artists such as Leonardo, Raphael, and Titian demonstrated. Thanks to its variety and richness, the oil painting – on canvas rather than panel – would become the most highly regarded type of picture up to the twentieth century.

Unlike a painting, a sculpture may be a fully three-dimensional image, standing alone. Or it may be a relief, projecting from a background of the same material. A relief has some of the

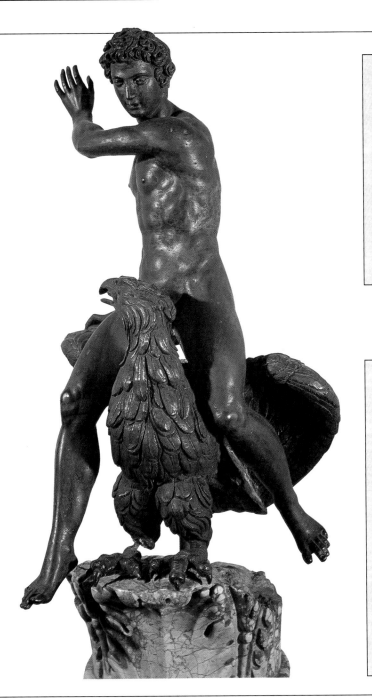

Casting in bronze

One method of bronze casting is the "lost wax" technique. The sculptor begins by making a clay model of the work, which is coated with a thin layer of wax. Then it is covered with plaster, which sets around it as a mold. Gentle heating causes the wax to run off through a vent. When molten bronze is poured in, it fills the space between the model and mould, taking on the shape of the missing skin of wax. Once it has cooled and hardened, the mold is broken open to reveal the finished work.

Women artists in the Renaissance

No woman would have been allowed to become a professional artist during the Renaissance; only boys were accepted as apprentices in the workshops where artists trained. But in some convents nuns had the chance to learn painting skills and to apply them. The Abbess Plautilla Nelli painted a large fresco, *The Last Supper*, in the church of Santa Maria Novella in Florence. Orsola Maddelena Caccia completed the murals her father had been working on before his death for the church in Moncalvo; she also organized a painting studio in her convent. And capable paintings were also produced by Sisters Barbara Ragnoni and Barbara Longhi.

characteristics of a two-dimensional picture, and sculptors of famous reliefs such as Ghiberti's *Gates of Paradise* (see page 9) learned from perspective and other artistic discoveries.

Sculpture was very important in the Renaissance, because of the influence of ancient Greek and Roman statuary, and the work of great sculptors such as Donatello and Michelangelo. Technically, the most striking changes were not in carving but in bronze sculpture, revived after centuries of neglect. The sculptor's creative work was actually done in clay, which was modeled into the required image; then it was converted into the more lasting form of bronze by a process known as casting. This was a difficult technical operation that sometimes resulted in the destruction of the clay model. The Renaissance made great progress in casting and produced some of its most spectacular masterpieces in bronze.

3 CLASSICISM

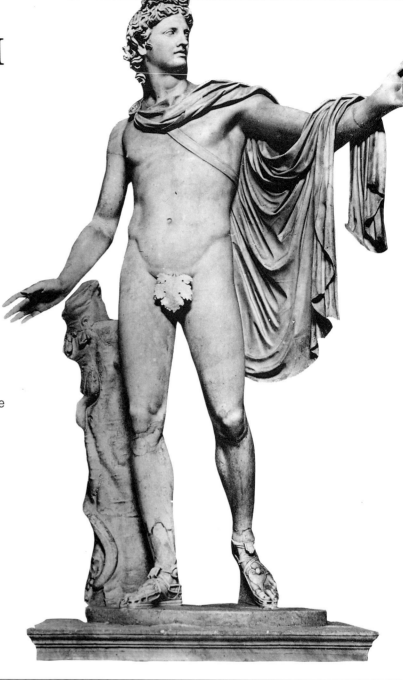

This Greco-Roman statue, the *Apollo Belvedere*, is a good example of the sculpture admired by Renaissance artists. It is lifelike, but it is also harmoniously proportioned, with an air of nobility and serenity. These qualities, which Renaissance people believed were typical of ancient Greek and Roman art, greatly influenced Renaissance ideas. *Vatican Museum, Rome.*

The civilizations of ancient Greece and Rome – "classical" civilization – dominated the Mediterranean region for over a thousand years. Its final phase was the Roman Empire, which spread as far as western Europe and England. In the fifth century A.D., the Roman Empire in the west collapsed, and its center moved east to Constantinople. New European peoples gradually built up the very different civilization of the Middle Ages.

The ruins of Roman cities, monuments, aqueducts, and roads deeply impressed the people of medieval Europe, who were unable to match such achievements for centuries. Medieval thinkers and builders tried to copy the ideas and methods of classical Greece and Rome, but they were wary of the fact that for most of the time this had been a pagan civilization. In time, they learned more about the classical past through Islamic civilization,

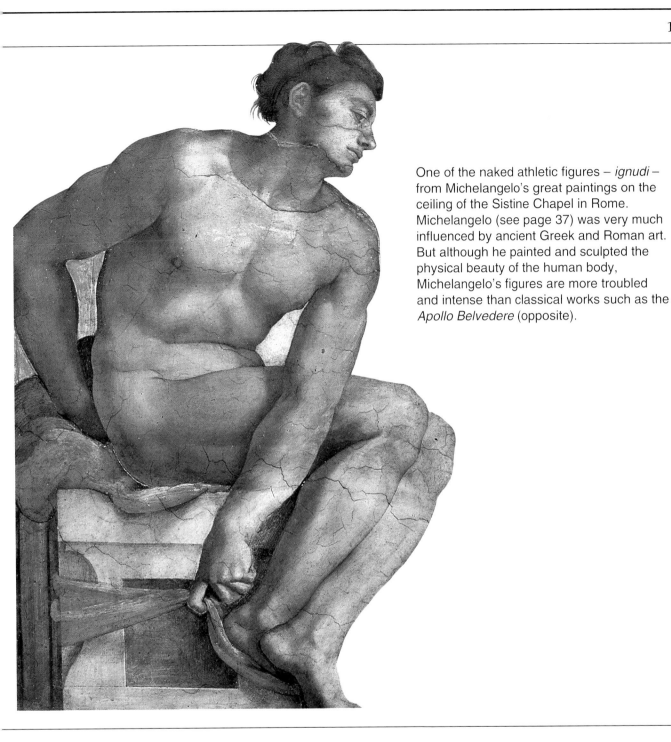

One of the naked athletic figures – *ignudi* – from Michelangelo's great paintings on the ceiling of the Sistine Chapel in Rome. Michelangelo (see page 37) was very much influenced by ancient Greek and Roman art. But although he painted and sculpted the physical beauty of the human body, Michelangelo's figures are more troubled and intense than classical works such as the *Apollo Belvedere* (opposite).

especially that of Spain, which had been ruled by Muslim Moors for centuries.

The influence of the classical past on the Renaissance was far stronger. Greco-Roman civilization set the standard by which Renaissance people judged almost everything, from literature to military tactics. In the visual arts – painting, sculpture, and architecture – classical works were greatly admired and

anything medieval was despised. Architects abandoned the pointed-arch Gothic style and began to build with the round arches, columns, and domes of the Romans (see chapter 8). Renaissance sculptors and painters studied and tried to improve upon the classical works that had been preserved over the centuries, or were being brought to light by excavations: a number of famous classical sculptures were actually discovered in Italy during the fifteenth century.

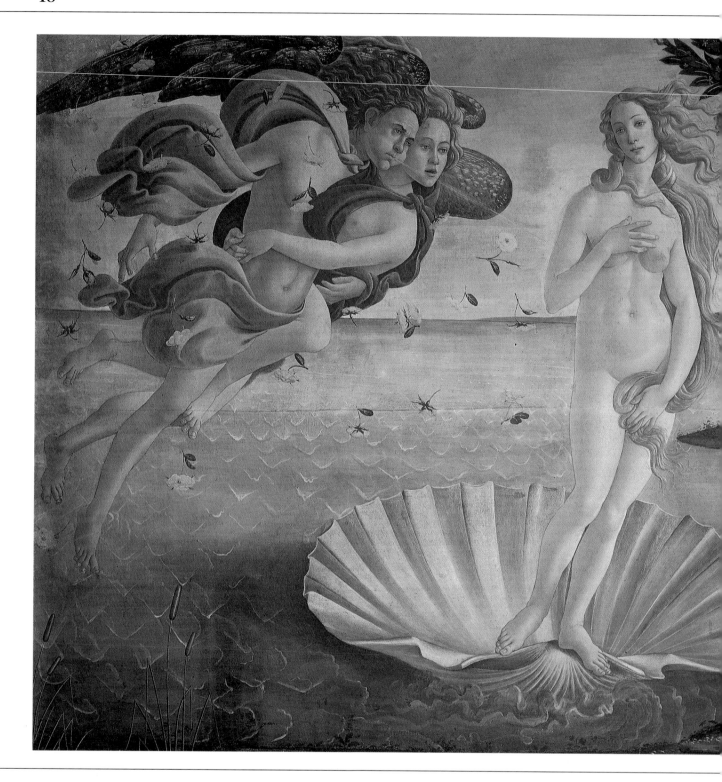

Most of the works known in Renaissance times were Roman or Roman copies of Greek works. They greatly influenced Renaissance artists, to whom all classical sculpture seemed noble, perfectly proportioned, serene, and beautiful. These were the qualities they tried to reproduce in their own works. That is why Renaissance art is naturalistic – mirroring the real world – but not entirely realistic. Generally speaking, it shows physically splendid people rather than ordinary, imperfect human beings and their flaws.

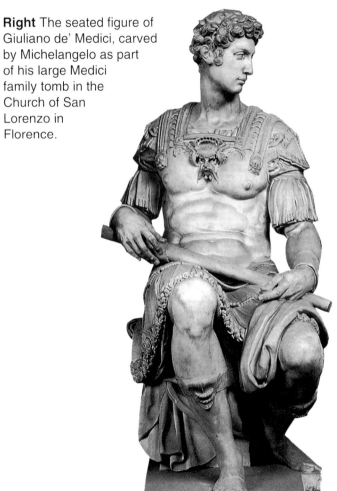

Left *Birth of Venus*. This mythological picture was painted in about 1490 by the Florentine artist Sandro Botticelli (1445-1510). Botticelli's delicate style made him a favorite of Florence's ruling Medici family. After the Medicis were driven out of the city in 1494, Botticelli's work seems to have become unfashionable, and he is said to have died in poverty. *Uffizi Gallery, Florence.*

Right The seated figure of Giuliano de' Medici, carved by Michelangelo as part of his large Medici family tomb in the Church of San Lorenzo in Florence.

Classical influences are very clear in the work of Renaissance sculptors – in their striving for beauty, and also in their revival of the idea of the nude as a subject for art. During the Middle Ages, the body was considered sinful, and naked human beings were rarely shown in art; the main exceptions were the sinful Adam and Eve and the shameful figures of tormented souls in Hell. But in classical art, nakedness was commonplace and the body was shown as splendid and beautiful. Inspired by this idea, Renaissance sculptors such as Donatello and

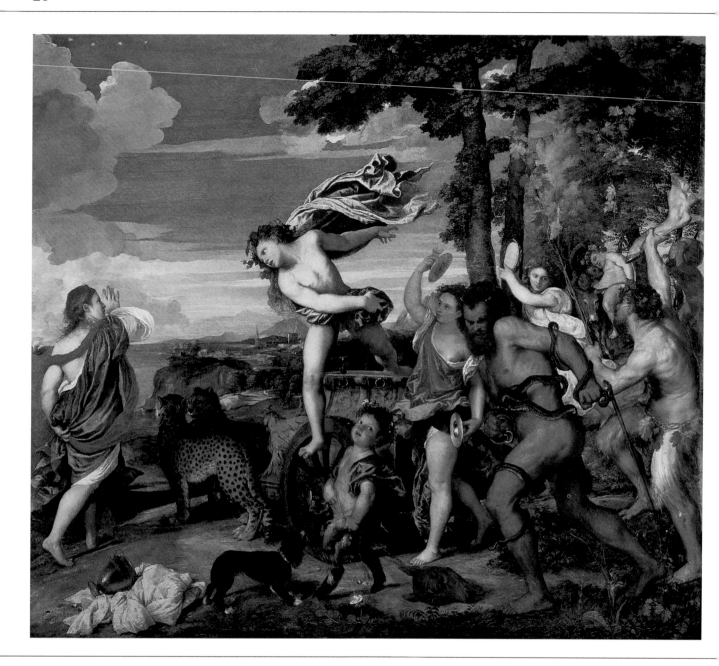

Michelangelo began the tradition in art of using the human body to express all sorts of effects and emotions.

The classical influence on Renaissance painting was much less than on sculpture, because only a few Greek and Roman paintings were known to have survived. However, Renaissance painters tried to live up to the classical ideals, and studied classical sculptures and descriptions of famous ancient works that no longer existed.

As well as influencing the Renaissance style, Greco-Roman civilization provided painters and sculptors with much of their subject matter. Although scenes from history were rare, there was a growing taste for art showing scenes from classical mythology – stories about the Greek and Roman gods, goddesses, and heroes. Art showing mythological subjects was encouraged by wealthy patrons such as merchants, because pictures were expected to "tell a story," and Greek and Roman myths were full of wonderful stories, varied enough

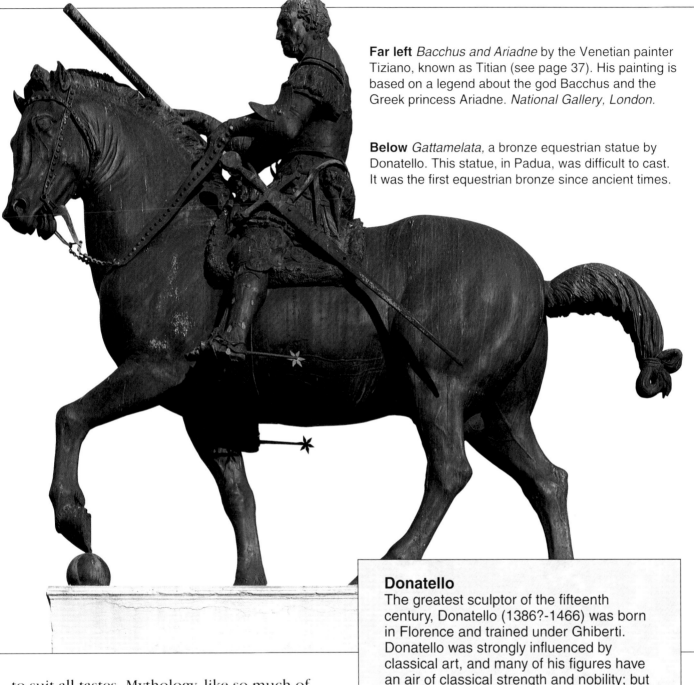

Far left *Bacchus and Ariadne* by the Venetian painter Tiziano, known as Titian (see page 37). His painting is based on a legend about the god Bacchus and the Greek princess Ariadne. *National Gallery, London.*

Below *Gattamelata,* a bronze equestrian statue by Donatello. This statue, in Padua, was difficult to cast. It was the first equestrian bronze since ancient times.

Donatello
The greatest sculptor of the fifteenth century, Donatello (1386?-1466) was born in Florence and trained under Ghiberti. Donatello was strongly influenced by classical art, and many of his figures have an air of classical strength and nobility; but they also have an emotional power that was new. Donatello created such famous works as the marble *St. George*, the bronze nude *David*, and the bronze monument to Gattamelata in Padua (see above).

to suit all tastes. Mythology, like so much of Renaissance art, remained part of the tradition of western art until modern times.

Although Renaissance artists revered classical art, they did not simply copy it. They worked in the spirit of their own time, and the greatest among them tried to match and even outdo the Greek and Roman artists. This meant that they had to catch up on techniques that had been unknown or neglected for many centuries. One of these techniques was working in

bronze, where Donatello was the first sculptor since antiquity to create a large, freestanding bronze nude (*David*), and the first to make a bronze equestrian statue (*Gattamelata*).

4 RELIGIOUS ART

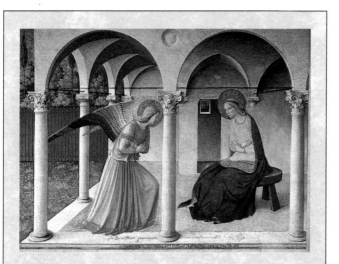

Fra Angelico
Fra Angelico (c.1400-1455) was a Dominican friar, vowed to a life of poverty. One of the greatest painters of the fifteenth century, he probably did not begin painting until the 1420s, but his work was soon in great demand. He traveled widely, painting in churches and monasteries, and was finally summoned by the Pope to work in Rome, where he later died. Among the most beautiful of his works are the frescoes, including the *Annunciation* (above), which were painted in the cells of the Dominican priory of San Marco in Florence.

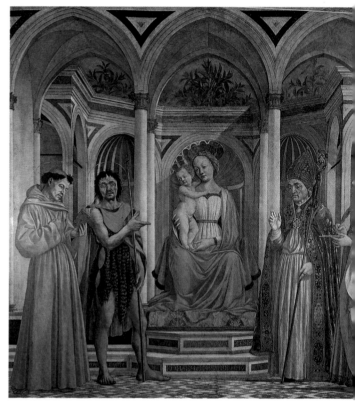

Madonna and Child with Saints, an altarpiece by Domenico Veneziano, "the Venetian" (1420-61), who in spite of his name, was probably a Florentine. This painting is an example of the *sacra conversazione* (see page 24). *Uffizi Gallery, Florence.*

The European Middle Ages have often been called "the Age of Faith," because religion seems to have held such a central place in the lives of medieval people. The art of the Middle Ages was also mainly religious, ranging from beautifully illustrated manuscript books (illuminated manuscripts) to the building of the great cathedrals.

In contrast to the religious attitudes of the Middle Ages, the Renaissance has sometimes been thought to have had a nonreligious outlook. But this was not really so, despite the strong influence of the pagan civilization of Greece and Rome. People were certainly more interested in secular (nonreligious) activities, and in the world around them, than their medieval ancestors had been. But there is no evidence that they believed any less in Christianity.

So although secular subjects became increasingly common as the Middle Ages gave way to the Renaissance, religion also remained vitally important, and the majority of works of art were still religious in their subject matter.

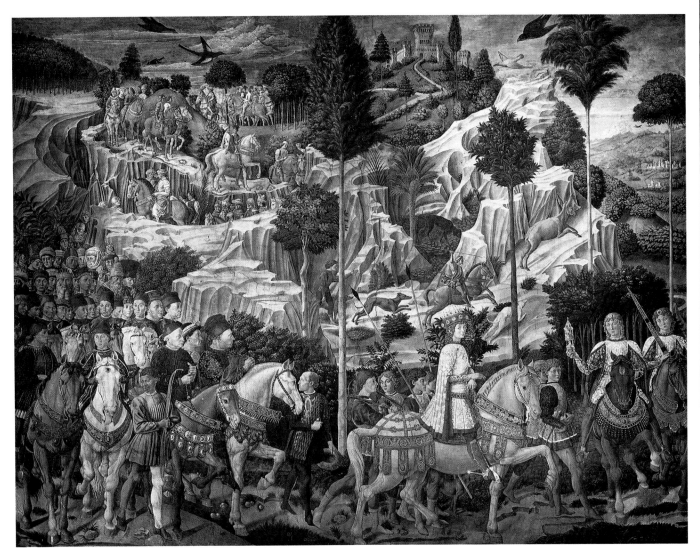

Journey of the Magi, a fresco by Benozzo Gozzoli. In this painting, the artist has portrayed Florence's ruling Medici family as the Wise Men who traveled to Bethlehem in order to see the newborn Jesus Christ. *Palazzo Medici, Florence*.

The Church continued to be the greatest patron of the arts, reaching the peak of its influence at Rome during the High Renaissance (see chapter 7). And although patronage outside the Church was becoming more common, a wealthy merchant was just as likely to order a religious as a nonreligious work of art – perhaps a sacred image or the furnishings for a chapel. Artists had not yet become specialists and a patron would expect a professional painter or sculptor to produce a work showing a Roman god or a Christian saint with equal skill and conviction.

But religious attitudes were slowly changing; people were becoming more aware of earthly beauty and the human side of religion. One sign of this was the increasing importance given to the Virgin Mary as a loving, merciful "Queen of Heaven." This new humanity was seen as early as the thirteenth century, in the frescoes of a great Florentine painter, Giotto (c. 1267-1337). The frescoes (see page 13) show events from the Gospels in a completely new way, so that, for example, Judas' betrayal of Christ with a kiss becomes a deeply human and dramatic event.

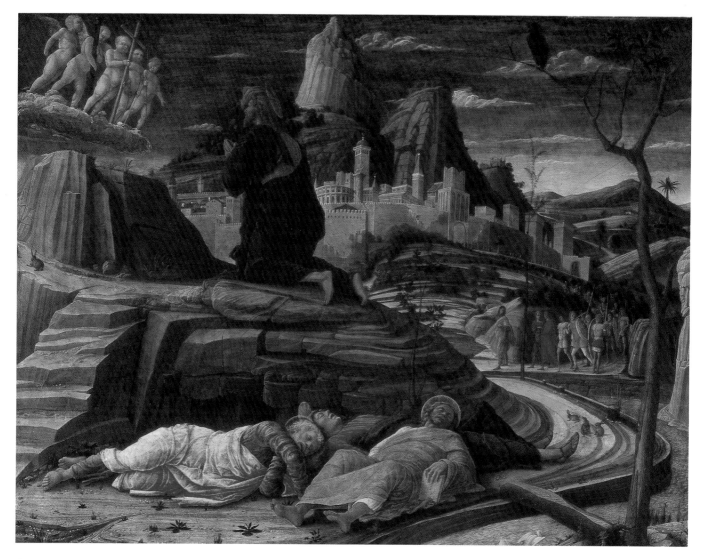

The Agony in the Garden by Andrea Mantegna. The artist was greatly influenced by the sculptor Donatello and his forms have an almost sculptured texture. *National Gallery, London.*

Giotto was exceptional, and he had no true successor until Masaccio appeared in the early fifteenth century. From this time on, the Renaissance produced a huge amount of religious art, showing stories from the Bible as taking place in the human and natural worlds.

This more human approach to religious art encouraged some artists to introduce new ideas. For example, medieval artists often painted a set of panels with the Madonna and Child in the center, isolated from the saints who flanked them in the panels on either side.

Renaissance painters such as Fra Angelico and Domenico Veneziano developed a new kind of single-panel picture, known as a *sacra conversazione* or "holy conversation," which brought the Madonna and Child and the saints into a closer relationship. Where single works of art showed mother and child alone together, Renaissance artists made the subject a celebration of tender motherhood.

There was also a change in the way the donor – the person who paid for an altarpiece for a church or monastery – was represented. The donor was usually shown on the altarpiece in a

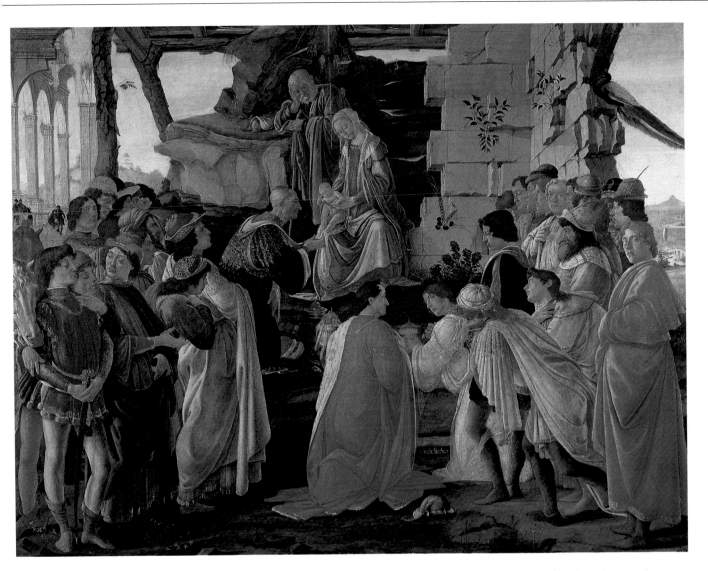

Adoration of the Magi, by Sandro Botticelli, includes tenderly reverent figures and, in contrast, frivolous bystanders. *Uffizi Gallery, Florence.*

scene with the Madonna, or with a saint – but in a humble pose and smaller than the holy figures. In both fifteenth-century Flanders and Italy artists abandoned this practice for a more naturalistic approach. At its most extreme, in Botticelli's *Adoration of the Magi* (c. 1475), the entire Medici court has turned up at the Nativity; the leading members of the family show a dignified awareness of their own worth, but attention is drawn to the courtiers on the fringe of the crowd, busy preening themselves and showing off. Even the artist, Botticelli, is there, his self-portrait gazing straight at the viewer.

The Medici appear again as the Magi, or Wise Men, in Benozzo Gozzoli's *Journey of the Magi* (1459). Although it is supposed to be concerned with the three wise men traveling to worship the newborn Christ, the painting seems more like an advertisement for the Medici and their followers, shown riding forth in all their splendor. However, although Renaissance artists obviously enjoyed such opportunities for display, in most cases they were able to combine the new naturalism with strong religious feeling, creating a fresh and distinctive kind of religious art.

5 PORTRAITS

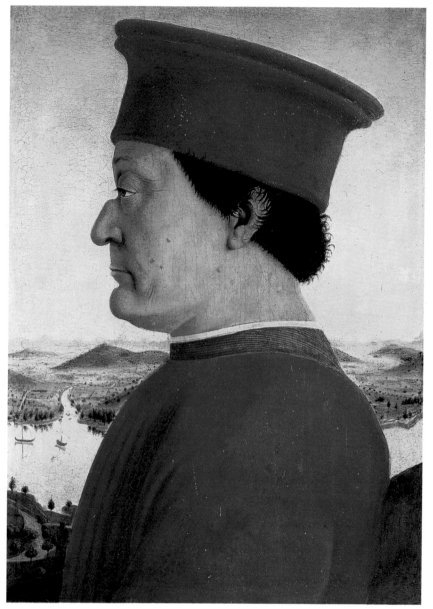

Above A portrait medal of the Florentine monk Giralamo Savonarola, who briefly held power in Florence (1494-98). He campaigned against "worldly vanities" before being overthrown and burned at the stake. *Bargello Gallery, Florence.*

Left *Federigo da Montefeltro*, a portrait by Piero della Francesca. Federigo was the Duke of Urbino, a city he made into one of the greatest cultural centers of the Renaissance. *Uffizi Gallery, Florence.*

Right *Portrait of a Man* by Titian, who was the greatest Venetian artist of his time. Among his finest works are a series of superb portraits. *National Gallery, London.*

The fifteenth century was the first great age of portraiture since ancient times. Renaissance patrons were extremely conscious of their own importance and were anxious to have themselves recorded in paintings. As Christians, they hoped for a place in heaven, but, like the heroes of the classical world whom they so admired, they also longed for earthly fame.

Early Renaissance portraiture was strongly influenced by classical portraits, especially the striking profiles of emperors shown in relief on Roman coins. These gave rise to an entirely new art form, the portrait medal. Leading artists such as Antonio Pisanello and Desiderio da Settignano produced portrait medals to honor famous individuals or to commemorate loved ones. Until the early

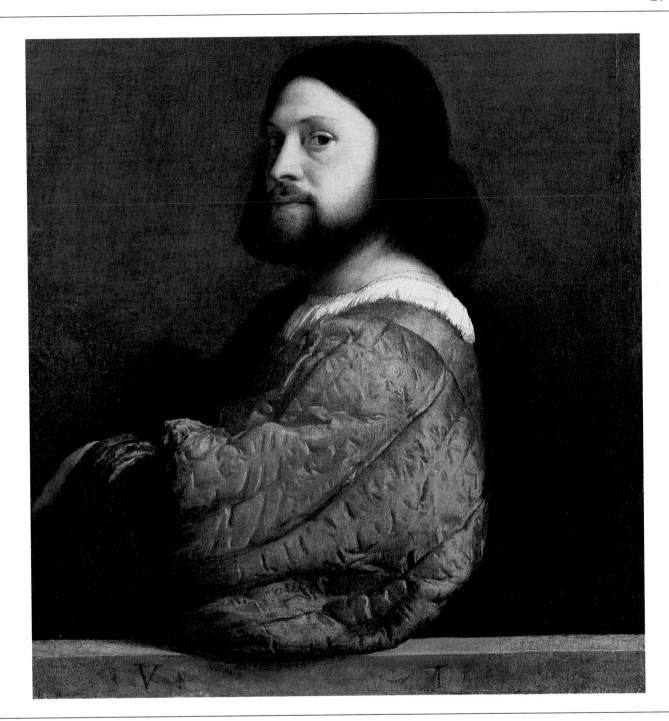

sixteenth century, these portrait medals were extremely popular.

From the mid-fifteenth century, sculptors carved the first portrait busts (showing head and shoulders) since classical times. Though inspired by Roman busts, Renaissance sculptors developed a slightly different form, showing more of the chest and arms.

During both the Middle Ages and the Renaissance, large, elaborately carved tombs were built for famous or wealthy people. Medieval tomb sculpture included a generalized figure intended to represent the dead person, laid out as though upon a deathbed. But on Renaissance tombs there was a recognizable portrait of the person, often shown as though still alive. For example, one

The *Mona Lisa*

The strange smile of the woman in this portrait was famous even during the Renaissance, and has fascinated generations of art lovers ever since. The picture's sense of mystery is created by Leonardo da Vinci's mastery of minute changes of tone (color value), his softening of the corners of Mona Lisa's mouth and eyes, and the melting landscape background. She was probably the wife of a Florentine merchant, who perhaps ordered the portrait from Leonardo, but the artist could not bear to give it up and kept it with him to the end of his life.

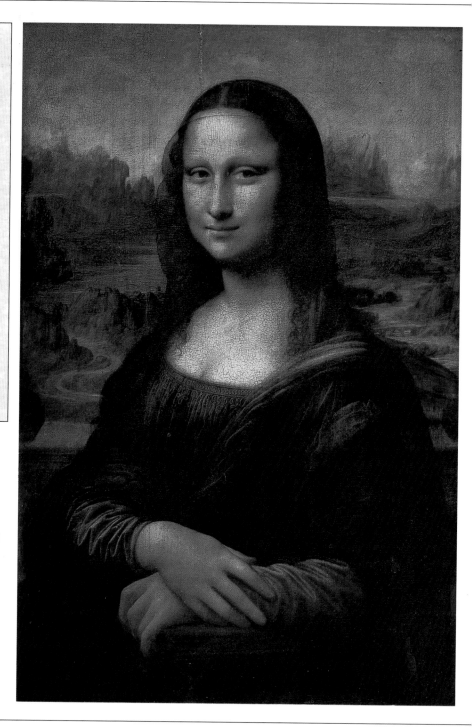

Right The *Mona Lisa* by Leonardo da Vinci (1452-1519) is probably the world's most famous painting. *Musée du Louvre, Paris.*

Far right *Doge Leonardo Loredan* by the Venetian artist Giovanni Bellini. The doge was the official head of the Venetian state, elected to rule for life. *National Gallery, London.*

of Michelangelo's masterpieces, the tomb of Giuliano de' Medici, shows Giuliano, dressed as a Roman general, sitting deep in thought (see picture on page 19).

For a long time, painted portraits showed the sitter in profile – possibly because this was a relatively easy way to capture a likeness. The profile remained popular because it seemed "Roman," in the same way as portrait medals. Piero della Francesca's double portrait of Federigo da Montefeltro and his wife Battista Sforza is a masterly example.

Later in the fifteenth century, Antonello da Messina and other artists began to paint three-

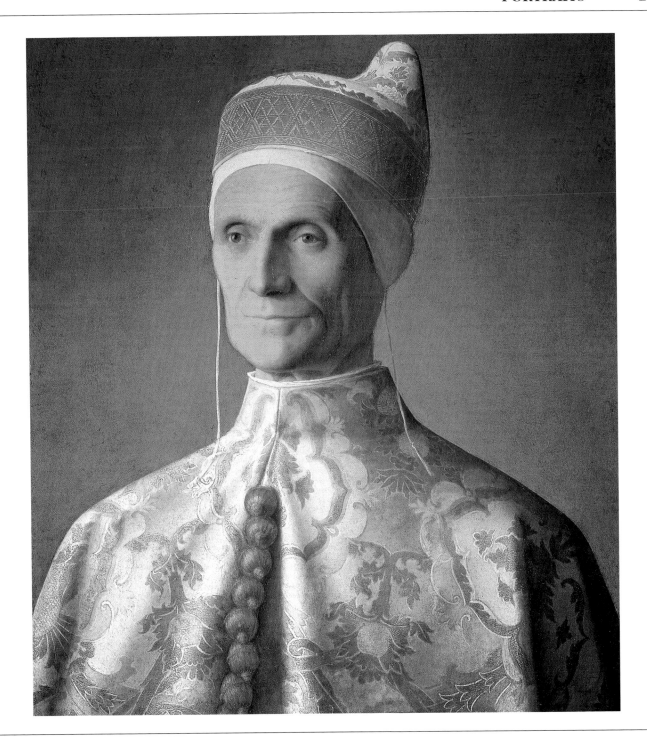

quarter view portraits (that is, with the sitter facing a little to one side). This became the standard pose, allowing the artist to paint facial features in a way that made the sitter seem solid and three-dimensional.

By the early sixteenth century the great Venetian tradition of portraiture was under way, with works such as Giovanni Bellini's *Doge Leonardo Loredan* (1501). Venetian portraiture reached its peak in the work of Titian, the first master to produce not one or two but a whole series of great portraits; while about the same time Leonardo da Vinci painted the *Mona Lisa*, surely the most famous portrait in the world.

6 LANDSCAPE

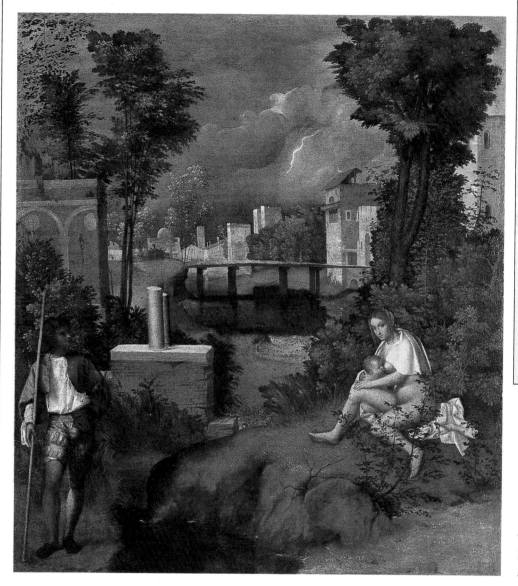

Painting nature's moods

The Venetian artist Giorgione da Castelfranco (c.1478-1510) introduced a new type of painting in which poetic feeling or "atmosphere" was more important than telling a story. In *The Tempest* (left) there seems to be no human drama, as the man and the woman are completely unaware of each other. The interest of the picture lies in its mood, heavy with the oppressive heat of a summer storm.

The Tempest by Giorgione. This is a rich, atmospheric landscape painting. *Academy Gallery, Venice.*

Most people enjoy being in the countryside and take pleasure in looking at a beautiful view. Perhaps that is why landscape paintings and drawings are popular. It is easy to imagine that landscapes have always been popular.

In reality, love of nature expressed through art has not been very common in human history; only the Chinese and Japanese have a long tradition of appreciating the landscape. In Europe, a feeling for nature developed in very slow stages. Medieval images of nature were rare, apart from those showing farmwork, the changing seasons (as in calendars), or single objects that were symbolic rather than lifelike. Toward the end of the Middle Ages, natural settings became more common, especially garden scenes featuring the Virgin Mary. But it was only from the fourteenth century that uncultivated nature began to appear in the backgrounds of pictures.

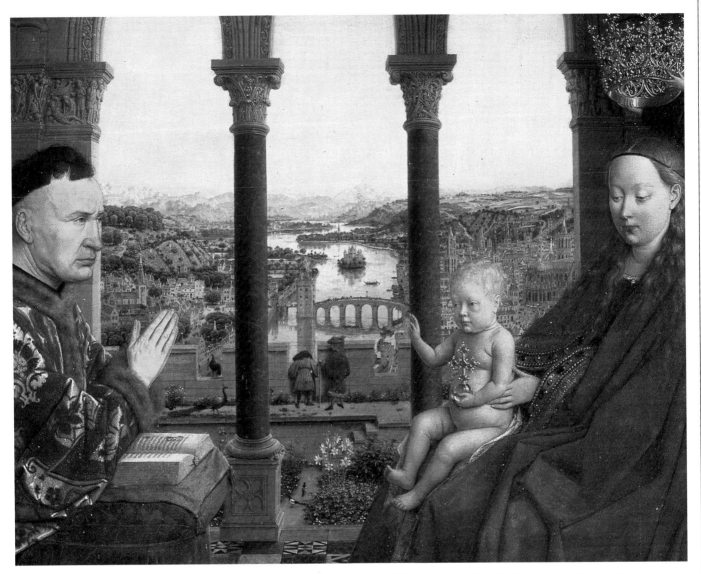

Detail from *Madonna of Chancellor Rolin* by Jan van Eyck. This brilliantly clear, detailed landscape is simply a background scene viewed through a window behind Chancellor Rolin and the Virgin and Child. *Musée du Louvre, Paris.*

These pictures might still contain symbolic meanings, but the landscapes shown in them were becoming convincing enough to be enjoyed for their own sake. In the fifteenth century, artists in northern Europe produced detailed landscape paintings in illuminated books as backgrounds to paintings such as van Eyck's *Madonna of Chancellor Rolin*, where lovely countryside is glimpsed through a window, stretching away to the horizon. The first picture of a recognizable place – the

shores of Lake Geneva – was *The Miraculous Draft of Fish* (1444) by the German-Swiss painter Konrad Witz.

During the same period, Italian artists were also introducing naturalistic backgrounds into their works. Landscape began to play a more positive, mood-creating role in the paintings of the Florentine Piero di Cosimo (1462-1521). In his strange and beautiful *Death of Procris*, the setting is mainly responsible for the

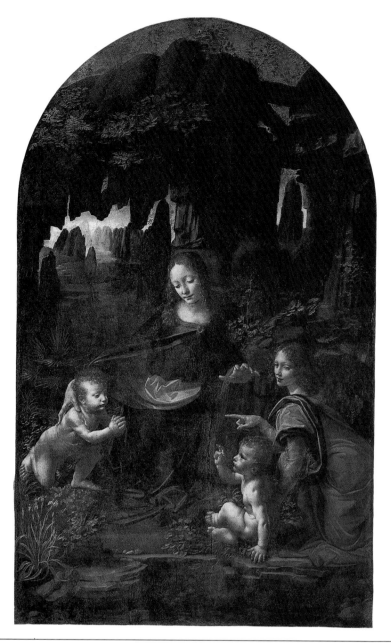

Above Detail from *Concert Champêtre* by Giorgione, showing landscape background. In later centuries, artists would make such a scene their main subject. (The complete painting appears on page 36.)

Left *Madonna of the Rocks* by Leonardo da Vinci. This is the earlier of two paintings of the subject by Leonardo. The setting, a rocky grotto, creates an unearthly atmosphere. *Musée du Louvre, Paris.*

mysterious sadness that seems to haunt the picture, and his *Forest Fire* (c. 1488) is the first known Italian painting in which human beings play only a minor role.

Leonardo da Vinci creates a different kind of strangeness in *Mona Lisa* and *Madonna of the Rocks*, setting his sweet, soft figures against an unexpectedly rocky background. However, the most notable "mood" painters of landscapes during the Renaissance were the Venetian artists Giovanni Bellini, Giorgione, and Titian.

Giorgione's *The Tempest* (page 30) is almost – but not quite – a pure landscape painting.

Although landscape in art was becoming more important, Italian Renaissance artists never painted it simply for its own sake, without people or story. The first artist known to paint landscape on its own was the German Albrecht Altdorfer (c.1480-1538), and he was ahead of his time. It was not until the 1620s, long after the Renaissance period, that pure landscape became an accepted style of art.

7 THE HIGH RENAISSANCE

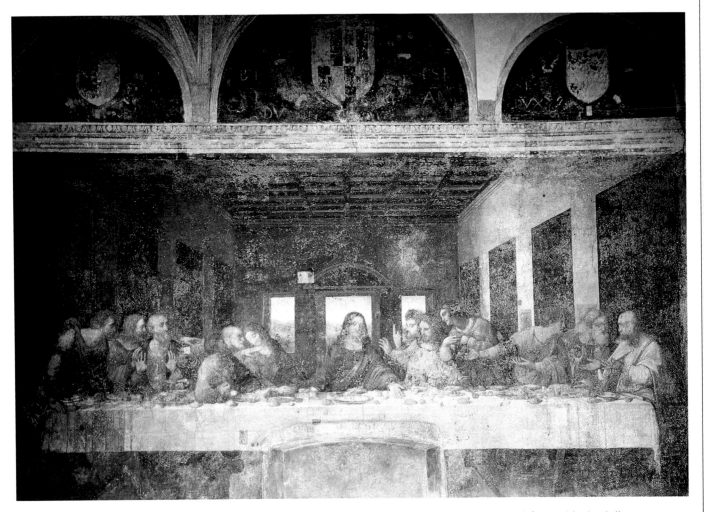

The Last Supper by Leonardo da Vinci. The grandeur of this great painting, on the wall of Santa Maria delle Grazie in Milan, can still be sensed, despite its very poor condition. Its condition is the result of Leonardo's decision to experiment with oil paints rather than use the more reliable fresco technique.

Fifteenth-century Italy produced many brilliant artists, but the Renaissance is generally believed to have reached its peak early in the sixteenth century. For a brief period, works were created in which complete technical mastery was combined with supreme self-confidence. This period, known as the High Renaissance, lasted from about 1500 to about 1527, and produced three artists – Leonardo, Michelangelo, and Raphael – who even during their own lifetimes were regarded as supermen.

Leonardo da Vinci (1452-1519) began his career in Florence, as an assistant in the workshop of the artist Verrocchio. His first known work is an angel painted in the corner of one of Verrocchio's pictures – and done so beautifully that Verrocchio is said to have given up painting in despair after seeing it.

Leonardo was soon recognized as one of the most extraordinary men of his time – a great painter and, among other things, a scientist, anatomist, military engineer, and musician.

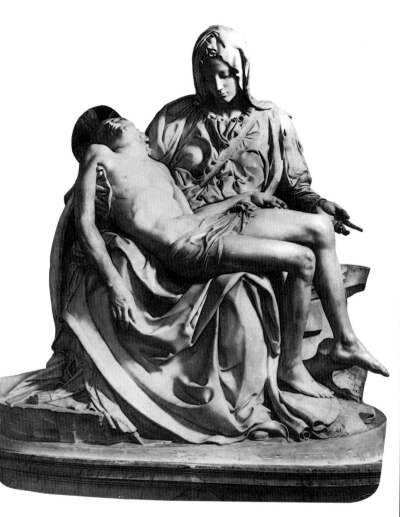

Left *Pietà* (1498-1500) by Michelangelo. This great sculpture, carved in marble, catapulted the young Michelangelo to fame. The pyramidal composition showing the grieving Virgin Mary cradling the dead Christ, and the calm quality of her sorrow, make this a masterpiece of the High Renaissance. *Vatican Museum, Rome.*

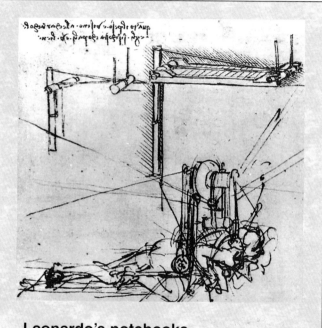

Leonardo's notebooks
Leonardo recorded the thoughts and studies of a lifetime in his notebooks, which were written in curious back-to-front "mirror writing" and not published until the 1880s. Among the thousands of pages were masses of notes on a great variety of subjects; sketches of people, landscapes, floods, and monsters; scientific drawings and anatomical studies; and remarkable anticipations of modern machines such as airplanes and tanks. Above is one of Leonardo's drawings of a flying machine.

He was also a strangely restless and dissatisfied individual, moving abruptly from one project to the next, and leaving most of the work he did unfinished. As a result, he left only a handful of paintings. He could be considered a failure as an artist – except that the handful are among the greatest of all works of art. People who saw them marveled at the haunting smiles on the faces of Leonardo's figures, and the way in which the tones (shades of color) in his paintings melted into one another instead of being separated by hard outlines. This technique, which Leonardo himself described as *sfumato* (smoky), showed the subtle effects that were possible with the new oil painting technique.

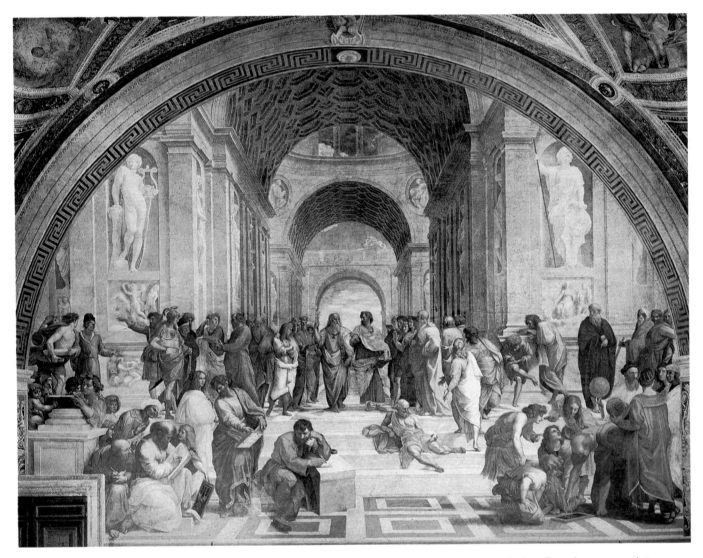

The School of Athens by Raphael is a marvelous example of the harmony and strength that Renaissance artists tried to achieve. It shows an imaginary group of ancient Greek philosophers, with Plato and Aristotle in the center. The head of the older philosopher, Plato, is said to be a portrait of Leonardo da Vinci. *Vatican Museum, Rome.*

Leonardo's compositions – often with the main figures arranged in a triangle – had a quality of strength and stability that became typical of the art of the High Renaissance.

Michelangelo Buonarroti (1475-1564) was a multitalented artist. He was a moody, difficult man, but powerful patrons, including popes and princes, put up with his bad temper because they realized that there was no other artist like him. Even as a young man, Michelangelo was famous as a sculptor.

He carved marble masterpieces such as the *Pietà* (the dead Christ in his grieving mother's lap, 1498-50) and the huge statue of the young David (1501-4). Heroic male figures such as *David* were Michelangelo's greatest contribution to art. They were inspired by the sculptures of ancient Greece and Rome, but their physical power and inner tension made them unique.

Although Michelangelo thought of himself as a sculptor rather than a painter, in 1508 Pope

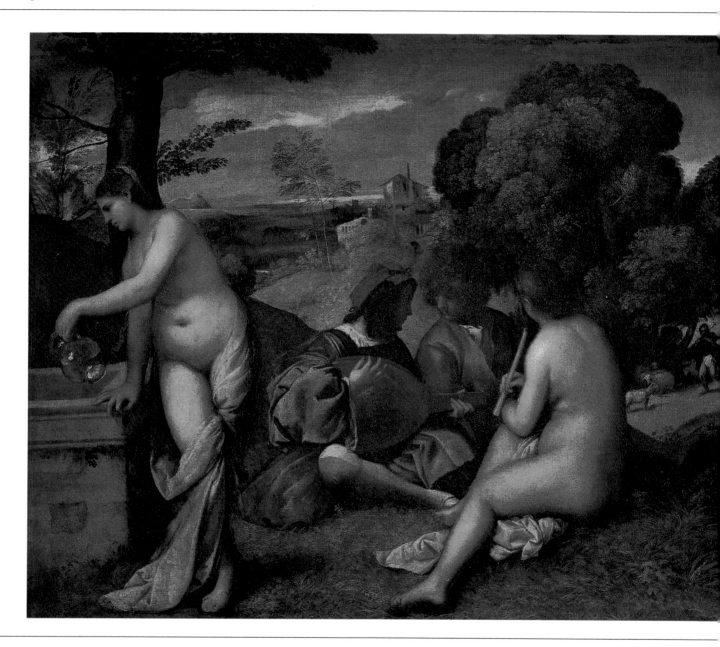

Julius II persuaded him to paint a large fresco to decorate the ceiling of the Sistine Chapel in Rome. From about this time Rome became the chief center of Renaissance art. Michelangelo labored for four years to complete a vast series of Biblical scenes, with hundreds of figures. It is difficult, even now, to believe that this work was created by just one man.

During Michelangelo's long career he achieved fame as a painter, sculptor, and architect. Unlike Leonardo and Raphael, he outlived the Renaissance, and in his later years he did

much to form the Mannerist artistic style that followed.

Raphael (whose real name was Raffaello Sanzio, 1483-1520) was more consistent than any of the other Renaissance artists in producing paintings that showed the serene grandeur and beauty of classical art, which was so admired. Where Leonardo's paintings are mysterious and Michelangelo's work is turbulent, Raphael created a serene, sunlit world, in which the figures combine spiritual feeling with a glowing physical beauty.

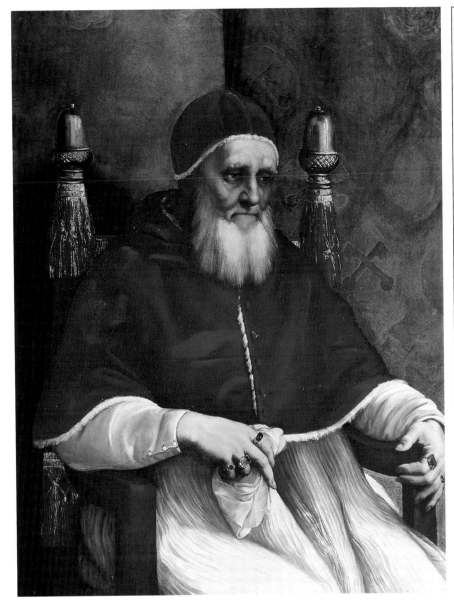

The Papacy
The Renaissance popes ruled over most of central Italy and were often more concerned with politics than with religion: Pope Julius II (1503-13) was so warlike that he was known as "the warrior pope." But in general, the popes' good taste – and their wish to be commemorated – made them great patrons of art. Under Julius II, Rome became the center of the Renaissance: this remarkable man employed Michelangelo in the Sistine Chapel and Raphael in the Vatican, while the great architect Bramante worked on designs for the magnificent new Church of St. Peter's – all at the same time.

Left *Portrait of Pope Julius II* by Raphael. This beautiful study of the warlike Pope in old age shows him looking unusually melancholy. *National Gallery, London.*

Far left *Concert Champêtre* by Giorgione. Scenes of aristocrats enjoying country pleasures became very popular. *Musée du Louvre, Paris.*

Raphael grew up in the important artistic center of Urbino, where his father was a court painter and writer. He was a pupil of Perugino and he probably worked on frescoes in the Sala del Cambio in Perugia. Even in his early twenties Raphael was recognized as a master. In 1508 he went to Rome, where he spent the remainder of his short life. His great frescoes in the Vatican, *The School of Athens* and *The Disputation*, bring together the classical and Christian worlds. His other works include superb portraits and a number of famous paintings of the Madonna and Child.

By about 1520 the Renaissance was coming to an end in most of Italy. But in the merchant republic of Venice, where it had arrived late, the Renaissance survived for a few more decades. The main Venetian artists were painters, and they were able to develop further the use of oil paints, using rich colors to produce glowing effects.

The most important Venetian painters were Giovanni Bellini (c. 1430-1516) and his pupils Giorgione (c. 1478-1510) and Titian (Tiziano Vecelli, c. 1488-1576). Very little is known about

Right *Creation of the Sun and Moon*, part of Michelangelo's vast paintings on the ceiling of the Sistine Chapel in the Vatican, Rome. There are nine main panels like this, showing events from the Bible, plus many surrounding figures and architectural features. When completed in 1512, Michelangelo's great frescoes covered some 5,600 square feet.

Giorgione, who died young from the plague, but he painted such atmospheric masterpieces as *Concert Champêtre* (page 36) and *The Tempest* (page 30). Some of his works may have been finished after his death by Titian, blurring the distinction between the early work of the two.

Titian himself was very long-lived, and his talent made him the most famous painter in Europe. By this time (c. 1520), although works of art were still being created for religious and decorative purposes, they were also beginning to be collected and appreciated for their own sake by people who are now called art lovers or connoisseurs. Titian's success ensured that the easel picture, painted in oils on canvas, would become the most admired form of painting in Europe. It continued to hold pride of place until the twentieth century.

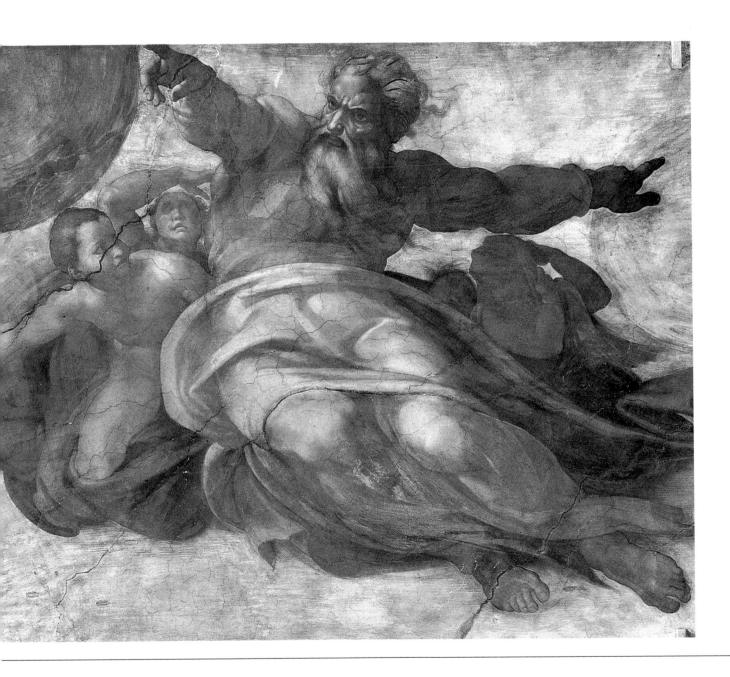

The mighty Holy Roman Emperor Charles V is said to have stooped to pick up one of Titian's paintbrushes. Whatever the truth of the story, it shows how greatly the artist's status had changed during the Renaissance. Once looked on as a simple craftsman – who might not even sign his name on the works he produced – the artist had steadily won much greater recognition. Finally, men like Leonardo and Michelangelo came to be seen as geniuses, exceptional people who were not subject to ordinary rules. One result of this change in outlook was that Giorgio Vasari, a sculptor and painter living at the time, wrote the first biographies of European artists (1550). The first full-length autobiography by an artist was written shortly afterward. These can be seen as the first "art books," showing that in this, as in so many other respects, the modern attitude toward art began with the Renaissance.

8 THE GREAT BUILDINGS

Right The Church of San Lorenzo in Florence was designed by Filippo Brunelleschi. By contrast with the mysterious interiors of Gothic churches, Brunelleschi's early Renaissance masterpiece is laid out clearly and simply, with mathematically exact proportions.

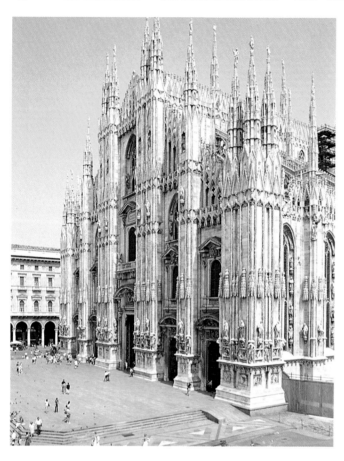

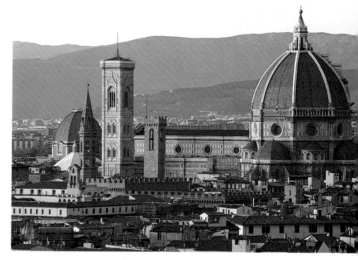

Above Milan Cathedral in northern Italy is an example of the Gothic style of architecture of medieval Europe. The pointed pinnacles, intricate decoration, and generally vertical appearance can be contrasted with the clean-cut simplicity of the Renaissance buildings shown elsewhere in this chapter.

Above Florence Cathedral was begun in 1296 and finished only in the early fifteenth century. Its crowning feature is the great dome, designed by Filippo Brunelleschi, which dominates the city's skyline.

Architecture, even more than the other arts, was completely transformed by Renaissance ideas. In fifteenth-century Italy only a few architects continued to build in the Gothic style, which had been used for the great medieval cathedrals of earlier centuries. Instead, they were inspired by the buildings of ancient Greece and Rome. Renaissance architects made a careful study of Roman buildings, adapting the classical style to their own needs.

The change from Gothic to Renaissance architecture was dramatic. The Gothic style of tall spires, pointed arches, and high, spacious interiors created a sense of mystery. By contrast, the Renaissance style used the imposing columns, round arches, and domes of Roman buildings. This architecture was more plain than the Gothic style, tending toward balance and symmetry. It is often described as "rational," meaning that everything in it is clearly and straightforwardly organized.

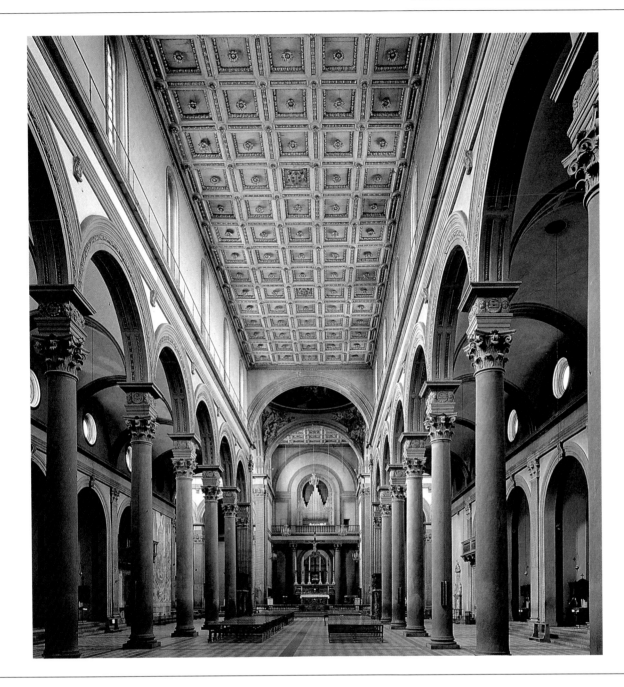

The first architect to revive the classical style was a Florentine, Filippo Brunelleschi (1377-1446). He started his career as a sculptor and goldsmith, but after losing the competition to make the Baptistery doors (shown on page 9) in Florence to Ghiberti, Brunelleschi turned from sculpture to architecture. He is also believed to have worked out the first system of scientific perspective and to have taught it to Masaccio, the youthful founder of Renaissance painting.

Starting in 1420, Brunelleschi worked on his masterpiece, the huge dome of Florence Cathedral. Its construction was a marvelous technical feat which established him as the greatest architect of his time. Among Brunelleschi's other works are the Church of San Lorenzo and the beautiful Pazzi Chapel, both in Florence.

Other Renaissance architects were Michelozzo di Bartolommeo and Leon Battista Alberti.

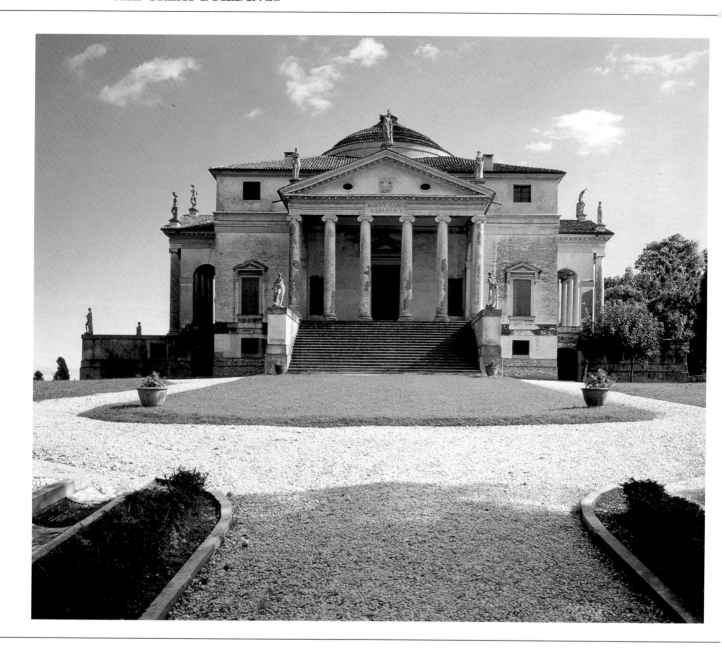

Michelozzo (1396-1472) designed the first Renaissance palace, the Palazzo Medici-Riccardi in Florence (1444). This kind of "palace" was more like a grand town house, often topped with a large cornice and built around a courtyard.

Alberti (1404-72) designed several fine classical buildings and also wrote guides to architecture, painting, and sculpture. He was a man of many talents, the type of "universal man" so greatly admired in the Renaissance. He was an architect, painter, writer, mathematician, and an athlete capable of jumping with both feet together over the head of a man standing up.

The greatest architect of the High Renaissance was Donato Bramante (1444-1514) who, like his friend Raphael, came from Urbino. After working for a long time as a painter and architect in Milan, Bramante moved to Rome in 1499. His Tempietto (1502) is a small circular chapel in the courtyard of a monastery, built on the spot where St. Peter is believed to have been martyred. Its perfect proportions are

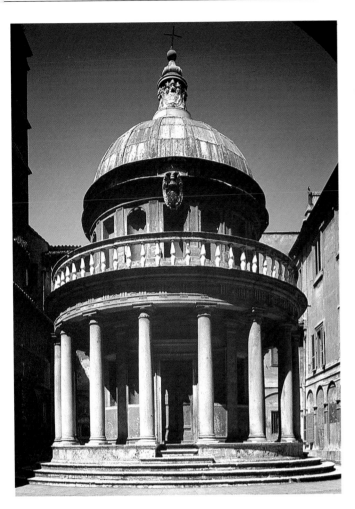

Left The Rotunda, built around 1580, is one of many villas designed by Andrea Palladio. A villa was a large, fancy country house; Palladio made this one fancier still by adding a portico and triangular pediment on each side.

Left The Tempietto of San Pietro in Rome, designed by Donato Bramante. This High Renaissance chapel looks just like a Roman temple. It is quite small but its perfect proportions give it an air of grandeur.

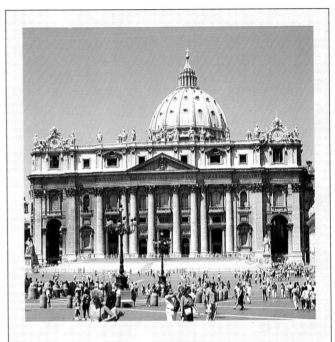

St. Peter's, Rome

St. Peter's in Rome is the largest of all Christian churches, built over the site where the apostle St. Peter is said to have been buried. In 1506 Pope Julius II ordered the existing church to be pulled down and commissioned Bramante to design a new building. After Bramante's death a series of architects, including Michelangelo, worked on the design. St. Peter's was finally finished in 1615, and in the 1650s the magnificent colonnaded square in front of the cathedral was added by Gianlorenzo Bernini (1598-1680).

typical of High Renaissance building, faithfully following the ideals of classical architecture. Bramante was chosen by Pope Julius II to design the new Church of St. Peter, but both the Pope and Bramante had died before much could be accomplished.

Among other High Renaissance artists, both Michelangelo and Raphael practiced architecture, and Bramante's pupils designed some of the finest buildings in Rome. The High Renaissance style was brought to Venice by Jacopo Sansovino, who began building the celebrated Library of St. Mark's there in 1536. Working around Venice and nearby Vicenza, Andrea Palladio (1508-80) was unusual in specializing in villas (grand country houses), whose elegant designs were to have a lasting influence on European architecture.

9 THE SPREAD OF THE RENAISSANCE

Right *The Last Judgment* by Michelangelo, on the altar wall of the Sistine Chapel, was completed in 1541, more than twenty years after his Sistine ceiling frescoes. This painting shows the darker mood that had replaced the bold, confident spirit of the Renaissance.

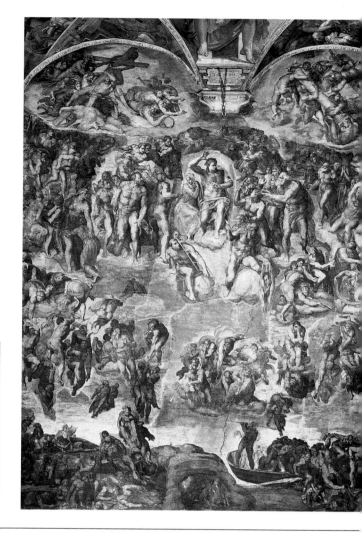

The Northern Renaissance
In the sixteenth century, the Renaissance made a great impact on northern Europe. Many of the new Italian techniques were brought back to Germany by Albrecht Dürer (1471-1528), who became celebrated for his paintings (including pioneering self-portraits) and also for superb engravings (see illustration on page 8).

By 1520 Leonardo, Raphael, and Bramante were dead. In 1527 the troops of the Emperor Charles V sacked the city of Rome. By 1530 the great days of the Florentine republic were over. At some point during these troubled years, the confidence and certainty of the High Renaissance ebbed away.

Political and religious changes brought about new attitudes, and these affected artistic styles. A new style, Mannerism, developed, which used Renaissance features such as naturalism and perspective, but in a very different way. In fact, Mannerism can be seen, not as a style, but as a set of reactions against the High Renaissance – turning away from grand, harmonious effects, sometimes toward tension and violence (as in the later works of Michelangelo), and sometimes toward extremes of elegance and refinement.

Meanwhile Renaissance scholars, books, and ideas, as well as art and artists, crossed the Alps into northern Europe. In fifteenth-century art this traffic was not all one way, because Flemish painting, in particular, greatly influenced the Italians. But by about 1500 Italy's position was unchallenged. Kings and rulers summoned Italian artists to decorate their palaces and carve their tombs. Renaissance art and ideas spread throughout Christian Europe in pictures, drawings, prints, and books – all the faster because printed books, first produced in 1448, were being turned out in ever greater numbers. A visit to Italy was already becoming the ambition of artists, art lovers and

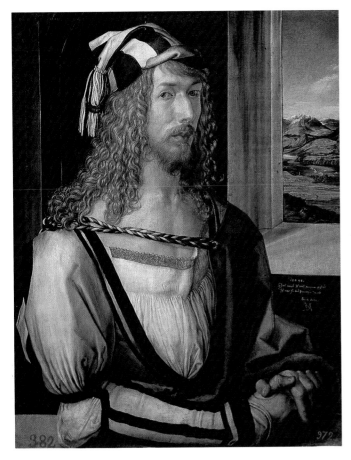

A typically self-questioning self-portrait by Dürer. He was possibly the first artist to paint a self-portrait as a completely independent work. *Prado, Madrid.*

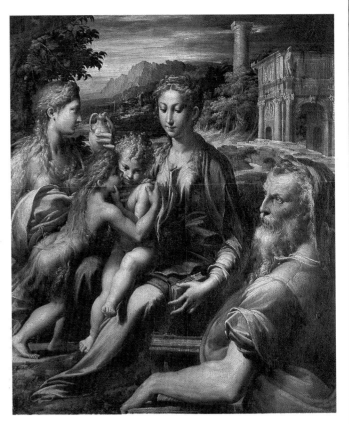

Madonna and Child with St. Zacharias by Francesco Parmigianino (1503-30). With its elongated figures and elaborate composition, this painting is typical of the new Mannerist style, which developed after the Renaissance. *Uffizi Gallery, Florence.*

fashionable people, beginning a tradition that has lasted for centuries.

Although the impact of Renaissance art on northern Europe was powerful, the sixteenth-century "Northern Renaissance" was not a simple imitation of the Italian original. Renaissance and Mannerist influences mingled and were altered almost everywhere by local traditions, by the upheaval of the Protestant Reformation, and by the very different northern outlook on the world.

The results can be seen in the work of the greatest artist of the Northern Renaissance, Albrecht Dürer (1471-1528). He visited Italy twice and spent years studying perspective, proportion, and Italian artistic theory.

But although some of Dürer's work is Italian in style, his self-portraits are northern in their intense self-examination, his nude figures are more often realistic than idealized, and engravings such as *The Four Horsemen of the Apocalypse* belong to a northern tradition of darkly grotesque imaginings.

The Renaissance was one of the great turning points in European art. In a sense, it has never ended. Naturalism, perspective, the nude, classicism – these and other features of Renaissance art did not disappear around 1520. They were only used in different ways in later styles. The Renaissance tradition has persisted into the twentieth century and, despite all the changes in modern art, is still going strong.

GLOSSARY

Altarpiece A work of art set above and behind the altar in a church.

Anatomy The science concerned with the physical structure of animals and plants.

Annunciation The New Testament story in which the Angel Gabriel appears to the Virgin Mary, telling her that she will be the mother of Jesus Christ.

Aqueduct A channel or bridge carrying a water supply.

Baptistery A building or part of a church where baptisms are carried out.

Barbaric Brutal and uncivilized.

Bronze A type of metal made from copper and tin.

Casting Pouring molten metal into a mold.

Classical Relating to the ancient Greeks and Romans.

Classicism An artistic attitude based on the study of ancient Greek and Roman art.

Colonnade A row of columns.

Cornice A decorative molding projecting at the top of a wall or building.

Engravings Prints taken from an engraved (cut) hard surface such as metal, wood, or stone.

Equestrian Having to do with riding horseback.

Excavation The digging up of buried objects.

Feudal A legal and social system, common in the Middle Ages, in which lords, knights, and serfs held land in return for services to their superiors.

Flemish Describes the people and territories of Flanders, which centuries ago covered parts of what are now Belgium and northern France.

Forms Shapes.

Fresco A way of painting directly onto newly plastered walls. The picture itself is also called a fresco.

Gospels The first four books of the New Testament of the Bible.

Gothic The style of architecture first used in western Europe from the twelfth to sixteenth centuries.

International Gothic A style of art during the late fourteenth and early fifteenth centuries, characterized by elegant decorative patterns, often of subjects taken from nature.

Islamic Relating to Islam, the religion of Muslims.

Mannerism The style of art that followed the Renaissance style.

Martyred Put to death for holding certain religious beliefs.

Medieval Describes the Middle Ages, usually thought of as the centuries between the end of the Roman Empire and the beginning of the Renaissance (from the fifth to fifteenth centuries).

Mural A large painting on a wall.

Mythology The study of traditional stories about heroes or gods and goddesses.

Nativity The birth of Jesus Christ. Scenes showing the newborn Jesus were popular in Christian art of the Middle Ages and the Renaissance.

Naturalism In art, a style in which the real appearance of things is faithfully shown.

Oil paints Paints made from ground pigments (colors) that are mixed and held together with linseed oil.

Pagan A word used to describe people who do not believe in the God of the Bible, especially followers of the ancient Greek and Roman religions.

Pediment A triangular feature (gable) projecting over a portico (entrance).

Perspective The science of showing objects in space on a two-dimensional (flat) surface.

Pietà A sculpture, painting, or drawing of the dead Christ in the lap of his mother Mary.

Pigments Natural substances used for making colors.

Portico A covered entrance to a building.

Protestant Reformation A religious movement in sixteenth-century Europe critical of the Catholic Church, which resulted in the establishment of the various Protestant Churches.

Relief A sculpture that stands out from a background of the same material but remains attached to it.

Secular Not concerned with or having anything to do with religion.

Symbolic Indicating or representing something else.

Tempera Painting made with pigments mixed with egg yolk and water.

Three dimensional Having depth as well as height and width.

Vanishing point In perspective (see above), the point on the horizon at which parallel lines seem to meet.

TIME LINE

c. 1280	Cimabue's *Madonna Enthroned*
1400-1500	Early Renaissance Period
1403	Ghiberti begins work on Baptistery Doors, Florence
1414	Medicis in power, Florence (to 1492)
1420	Brunelleschi designs dome of Florence Cathedral
1421-1429	Brunelleschi designs Church of San Lorenzo, Florence
c. 1427	Masaccio's *The Tribute Money,* using solid, three-dimensional figures
1433-1434	Van Eyck's *Madonna of Chancellor Rolin* using detailed landscape
1434	Van Eyck's *Arnolfini Wedding* Florence Cathedral completed
1443-1453	Donatello's equestrian monument *Gattamelata,* Padua, Italy
c. 1445	Veneziano's St. Lucy Altarpiece *Madonna and Child with Saints*
1450	Florence is center of Renaissance
1456	Ucello's *The Battle of San Romano*
1459	Gozzoli's *Journey of the Magi*
c. 1466	Mantegna's *Dead Christ*
1469	Lorenzo de' Medici rules Florence (to 1492)
c. 1474	Piero Della Francesca paints portrait of Federigo da Montefeltro, Duke of Urbino
c. 1475	Botticelli's *Adoration of the Magi* Pollaiuolo's *Martyrdom of Saint Sebastian*
1482	Botticelli's *Birth of Venus*
c. 1483	Da Vinci's *Madonna of the Rocks*
c. 1490	Piero di Cosimo's *The Death of Procris*
1495	Da Vinci's *Last Supper*
c. 1498	Dürer's engraving *The Four Horsemen and the Apocalypse*
1498	Michelangelo's *Pietà* Dürer's *Self Portrait* Savonarola burned at stake in Florence
1500	High Renaissance period begins
1501	Bellini's *Doge Leonardo Loredan* Michelangelo's *David*
1502	Bramante designs Tempietto di San Pietro, Rome
1503	Da Vinci's *Mona Lisa* Pope Julius II (to 1513) Rome is center of Renaissance
1505	Raphael's *Madonna of the Meadows*
c. 1505-1510	Giorgione's *Concert Champêtre*
c. 1508	Giorgione's *The Tempest.* Landscape painting established
1508-1512	Michelangelo paints Sistine Chapel ceiling
c. 1509-1511	Raphael's *The School of Athens*
1513	Dürer's *Knight, Death, and the Devil*
1519	Charles V, Holy Roman Emperor (to 1556) Mannerism art style follows Renaissance
1527	Sack of Rome Art treasures looted High Renaissance ends

FURTHER READING

Arenas, Jose F. *The Key to Renaissance Art.* Minneapolis: Lerner Publications, 1990.

Casselli, Giovanni. *The Renaissance and the New World.* New York: Peter Bedrick Books, 1986.

Howarth, Susan. *Renaissance People.* Brookfield, CT: Millbrook Press, 1992.

Howarth, Susan. *Renaissance Places.* Brookfield, CT: Millbrook Press, 1992.

Janson, H. W. and Janson, Anthony F. *The History of Art for Young People.* 4th edition. New York: Harry N. Abrams Inc., 1992.

Lace, William W. *Michelangelo.* San Diego: Lucent Books, 1993.

McLanathan, Richard. *Leonardo da Vinci.* First Impressions. New York: Harry N. Abrams Inc., 1990.

Shissler, Barbara. *The New Testament in Art.* Minneapolis: Lerner Publications, 1970.

Skira-Venturi, Rosabianca. *A Weekend with Leonardo Da Vinci.* New York: Rizzoli International, 1993.

FOR YOUNGER READERS

DISCOVERING ART series by Christopher McHugh (New York: Thomson Learning, 1993).

LOOK INTO THE PAST series by various authors (New York: Thomson Learning, 1993-1994).

INDEX

Franklin Pierce College Library

00144854

DATE DUE